校園武術普及教材

五步拳

YouTube
學習五步拳

掃碼學習五步拳

Five Steps Fist

Standard School Wushu Curriculum

《國際武術大講堂系列教學》
編委會名單

名 譽 主 任：冷述仁

名譽副主任：桂貴英

主　　　　任：蕭苑生

副　主　任：趙海鑫　張梅瑛

主　　　編：冷先鋒

副　主　編：鄧敏佳　鄧建東　陳裕平　冷修寧

　　　　　　冷雪峰　冷清鋒　冷曉峰　冷　奔

編　　　委：劉玲莉　張貴珍　李美瑤　張念斯

　　　　　　葉旺萍　葉　英　陳興緒　黃慧娟（印尼）

　　　　　　葉逸飛　陳雄飛　黃鈺雯　王小瓊（德國）

　　　　　　梁多梅　ALEX（加拿大）　PHILIP（英國）

顧　　　問：何光鴻　馬春喜　于存亮　陳炳麟

法律顧問：王白儂　朱善略　劉志輝

《五步拳》
編委會名單

主　編：冷先鋒

副主編：余芷瑄　王振名（台湾）

編　委：邓敏佳　冷飛鴻　陳鳳萍（美国）　吴津津（马来西亚）

　　　　冷飛彤　黄　嫣　陳曉澄　冷熙然　Connie Wong（澳门）

　　　　黄慧娟（印尼）　林敬朗　包　正　青木嘉教（日本）

　　　　Simon Leung（澳大利亚）　陳坚良　艾　力（加拿大）

　　　　洪添荣（新加坡）　方笑芬（法国）　鄧金超　冷　余

　　　　Philip（英国）

翻　譯：　Philip Reeves（英國）　Alex Nasr（加拿大）

金子樺（香港）XiaoQiong Wang（德國）　Yeung Wing Yee（美國）

《五步拳》簡介

五步拳是中國優秀的武術拳種之一。屬於查拳入門拳術套路，也是學習國際標準武術入門之基本拳術組合套路，是青少年（中小學生、幼稚園）學習武術的初級必學套路，他包含了武術中最基本的弓、馬、僕、虛、歇五種步型；拳、掌、勾三種手型；上步、退步等步法以及摟手、沖拳、按掌、穿掌、挑掌、架打、蓋打等手法。通過五步拳的練習可以增進身體的協調能力，掌握動作與動作之間的銜接要領，提高動作品質，為進一步學習武術打下基礎。

1998 年中國武術界吸收段位制的觀念，成立武術段位制，並頒佈段位制教材；段位教材將五步拳為入段的唯一教材。從此五步拳建立起在武術學習中最基礎套路的獨特地位，無論是長拳、南拳、太極拳、散手或其他傳統門派拳術，都以五步拳為入門基礎套路。

Introduction to Five-steps Fist

Five-steps fist (wubuquan) is one of the excellent martial arts of China. It belongs to a Chaquan introductory boxing routine and is also an introductory set of basic boxing techniques for learning international standard martial arts. It is a must for young people (kindergarten, elementary and middle school) learning martial arts. It includes the fundamental bow, horse, drop, empty and rest stances; fist, palm and hook hand forms; step forward, step back and other footwork, and gather arm, punch fist, press palm, pierce palm, raise palm, lift strike, cover strike and other techniques. Through practicing five-steps fist one can improve co-ordination, master the essential flow of one movement to the next, improve the quality of each movement and lay the foundations for further study of martial arts.

In 1998 the Chinese martial arts community assimilated the concept of a rank system, establishing martial arts rankings and promulgating rank-based teaching materials, of which five-steps fist was the only entry-level teaching. Since then, five-steps fist has established a unique position as the foundation routine in learning martial arts. Whether it is Changquan, Nanquan, Taijiquan, Sanshou, or other traditional martial arts, five-steps fist is the foundation routine.

冷先鋒簡介

　　江西修水人，香港世界武術大賽發起人，當代太極拳名家、全國武術太極拳冠軍、香港全港公開太極拳錦標賽冠軍、香港優秀人才，現代體育經紀人，自幼習武，師從太極拳發源地中國河南省陳家溝第十代正宗傳人、國家非物質文化遺產傳承人、國際太極拳大師陳世通大師，以及中國國家武術隊總教練、太極王子、世界太極拳冠軍王二平大師。

　　中國武術段位六段、國家武術套路、散打裁判員、高級教練員，國家武術段位指導員、考評員，擅長陳式、楊式、吳式、武式、孫式太極拳和太極劍、太極推手等。在參加國際、國內大型的武術比賽中獲得金牌三十多枚，其學生弟子也在各項比賽中獲得金牌四百多枚，弟子遍及世界各地。

　　二零零八年被香港特區政府作為"香港優秀人才"引進香港，事蹟已編入《中國太極名人詞典》、《精武百傑》、《深圳名人錄》、《香港優秀人才》；《深圳特區報》、《東方日報》、《都市日報》、《頭條日報》、《文彙報》、《香港01》、《星島日報》、《印尼千島日報》、《國際日報》、《SOUTH METRO》、《明報週刊》、《星洲日報》、《馬來西亞大馬日報》等多次報導；《中央電視臺》、《深圳電視臺》、《廣東電視臺》、《香港無線 TVB 翡翠臺》、《日本電視臺》、《香港電臺》、《香港商臺》、《香港新城財經臺》多家媒體電視爭相報導，並被美國、英國、新加坡、馬來西亞、澳大利亞、日本、印尼等國際幾十家團體機構聘為榮譽顧問、總教練。

　　冷先鋒老師出版發行了一系列傳統和競賽套路中英文 DVD 教學片，最新《八法五步》、《陳式太極拳》、《長拳》、《五步拳》、《陳式太極劍》、《陳式太

極扇》、《太極刀》等太極拳中英文教材書，長期從事專業的武術太極拳教學，旨在推廣中國傳統武術文化，讓武術太極拳在全世界發揚光大。

　　冷先鋒老師本著"天下武林一家親"的理念，以弘揚中華優秀文化為宗旨，讓中國太極拳成為世界體育運動為願景，以向世界傳播中國傳統文化為使命，搭建一個集文化、健康與愛為一體的世界武術合作共贏平臺，以平臺模式運營，走產融結合模式，創太極文化產業標杆為使命，讓世界各國武術組織共同積極參與，達到在傳承中創新、在創新中共享、在共用中發揚。為此，冷先鋒老師於 2018 年發起舉辦香港世界武術大賽，至今已成功舉辦兩屆，盛況空前。

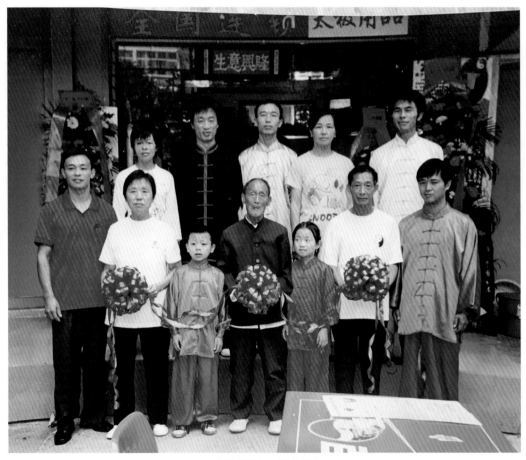

太極世家　　四代同堂

Profile of Master Leng Xianfeng

Originally from Xiushui, Jiangxi province, Master Leng is the promoter of the Hong Kong World Martial Arts Competition, a renowned contemporary master of taijiquan, National Martial Arts Taijiquan Champion, Hong Kong Open Taijiquan Champion, and person of outstanding talent in Hong Kong. A modern sports agent, Master Leng has been a student of martial arts since childhood, he is a 11th generation direct descendant in the lineage of Chenjiagou, Henan province – the home of taijiquan, and inheritor and transmitter of Intangible National Cultural Heritage. Master Leng is a student of International Taiji Master Chen Shitong and Taiji Prince, Master Wang Erping, head coach of the Chinese National Martial Arts Team and World Taiji Champion.

Master Leng, level six in the Chinese Wushu Duanwei System, is a referee, senior coach and examiner at national level. Master Leng is accomplished in Chen, Yang, Wu, Wu Hao and Sun styles of taijiquan and taiji sword and push-hands techniques. Master Leng has participated in a series of international and prominent domestic taijiquan competitions in taiji sword. Master Leng has won more than 30 championships and gold medals, and his students have won more than 400 gold medals and other awards in various team and individual competitions. Master Leng has followers throughout the world.

In 2008, Master Leng was acknowledged as a person of outstanding talent in Hong Kong . His deeds have been recorded in a variety of magazines and social media. Master Leng has been retained as

an honorary consultant and head coach by dozens of international organizations in the United States, Britain, Singapore, Malaysia, Australia, Japan, Indonesia and other countries.

Master Leng has published a series of tutorials for traditional competition routines on DVD and in books, the latest including "Eight methods and five steps", "Chen-style taijiquan", "Changquan", "Five-steps Fist" and "Chen-style taiji sword","Chen-style taiji fan","Taijidao". Master Leng has long been engaged as a professional teacher of taijiquan, with the aim of promoting traditional Chinese martial arts to enable taijiquan to spread throughout the world.

Master Leng teaches in the spirit of "a world martial arts family", with the goal of "spreading Chinese traditional culture, and achieving a world-wide family of taijiquan." He promotes China's outstanding culture with the vision of "making taijiquan a popular sport throughout the world". As such, Master Leng has set out to to build an international business platform that promotes culture, health and love across the world of martial arts practitioners to achieve mutual cooperation and integrated production and so set a benchmark for the taiji culture industry. Let martial arts organizations throughout the world participate actively, achieve innovation in heritage, share in innovation, and promote in sharing! To this end, Master Leng initiated the Hong Kong World Martial Arts Competition in 2018 and has so far successfully held two events, with unprecedented grandeur!

 # 冷先鋒太極（武術）館

中華武術

火熱招生中……

地址：深圳市羅湖區紅嶺中路1048號東方商業廣場一樓、三樓

電話：13143449091　　13352912626

【名家薈萃】

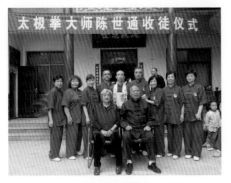

陳世通收徒儀式

王二平老師

趙海鑫、張梅瑛老師

武打明星梁小龍老師

王西安老師

陳正雷老師

余功保老師

林秋萍老師

門惠豐老師

張山老師

高佳敏老師

蘇韌峰老師

李德印教授

錢源澤老師

張志俊老師

曾乃梁老師

郭良老師

陳照森老師

張龍老師

陳軍團老師

【名家薈萃】

劉敬儒老師

白文祥老師

張大勇老師

陳小旺老師

李俊峰老師

戈春艷老師

李德印教授

馬春喜、劉善民老師

丁杰老師

付清泉老師

馬虹老師

李文欽老師

朱天才老師

李傑主席

陳道雲老師

馮秀芳老師

陳思坦老師

趙長軍老師

【獲獎榮譽】

【電視采訪】

【電視采訪】

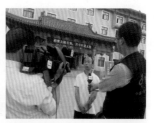

【電臺訪問】

【合作加盟】

【媒體報道】

【培訓瞬間】

百城千萬人太極拳展演活動　　　　　雅加達培訓

汕頭培訓　　　　王二平深圳培訓　　　　師父70大壽

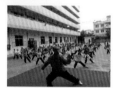
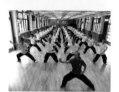

香港公開大學培訓　　印度尼西亞培訓　　松崗培訓　　香港荃灣培訓

王二平深圳培訓　　　陳軍團香港講學　　　印尼泗水培訓

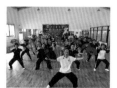

油天培訓　　　印尼扇培訓　　　七星灣培訓　　陳軍團香港講學培訓

油天培訓　　　　美國學生　　　　馬春喜香港培訓班

【賽事舉辦】

首屆世界太極拳交流大會

第二届"太極羊杯"香港世界武術大賽

第二届"太極羊杯"大賽

日本德島國際太極拳交流大會

首屆世界太極拳交流大會

馬來西亞武術大賽

東莞擂臺表演賽

首屆永城市太極拳邀請賽

首屆永城市太極拳邀請賽

2018首屆香港太極錦標賽

2019首屆永城市太極拳邀請賽

【專賣店】

五步拳，是指弓、馬、僕、虛、歇五種最常見的步型：

弓步：可以鍛煉腿部肌肉，常見於少林拳、太極拳等拳術

馬步：除了增大下肢力量，亦有助訓練髖關節，洪拳的四平大馬便是一例

僕步：可以鍛煉身體的柔韌性，在諸如華拳、紅拳等長拳類武術中佔重要地位

虛步：前虛後實，保持穩定性及靈活性，跟形意拳的三體步及太虛拳的吊步功能相近

歇步：兩腿交叉靠攏全蹲，左腳全腳著地、右腳前腳掌著地，主要是訓練腰胯協調性。少林長拳中亦有此動作

而在手法上，五步拳則有拳、掌、勾三種手型

可以見到，勾手與太極拳的單鞭手型一致

至於動作方面，由於五步拳乃取材自長拳，架式會相對大開大合，亦有抬腿、提膝的動作，例如馬步架打、提膝仆步穿掌等，對習者的體能要求比較高。

要打好五步拳，必須手步協調，每一下都要做得到位，並顯示出應有的力量。而其他細節，例如眼神等，亦要把握得好。這些要點在套路比賽中尤其重要，特別是五步拳本身便招式不多，動作質量自然是首要考慮。

"Five-steps fist" refers to the five most common bow, horse, drop, empty and rest stances:

Bow stance: exercises leg muscles, commonly seen in Shaolin, Taijiquan and other boxing techniques.

Horse stance: in addition to increasing lower limb strength, it also helps to train the hip joint – for example the "straddling a great horse" stance of Hongquan.

Drop stance: exercises flexibility of the body, and plays an important role in the martial arts of Changquan such as Huaquan, Hongquan, etc.

Empty stance: The front foot is empty and the rear foot is solid, maintaining stability and flexibility, similar to the three-body step of Xingyiquan and the hanging step of Taixuquan.

Rest stance: Squat fully with legs crossed close together, left foot flat on the ground and right foot resting on the forefoot, mainly to train waist and hip coordination – Shaolin Changquan also has this action.

In terms of technique, five-steps fist has three hand forms: fist, palm and hook.

It can be seen that the hook shape is identical to the single whip shape of Taijiquan.

As for the movements, since five-steps fist is derived from Changquan (long fist), the frame of opening and closing movements is large, and there are also movements in which the leg is raised or the knee is lifted, such as horse stance lift strike, lift knee drop stance pierce palm, etc. It is quite physically demanding.

To do five-steps fist well, you must co-ordinate hand and step, with movements precise at every point and displaying the proper force. You must also have a good grasp of other details such as the expression of the eyes. These points are particularly important in competition routines, especially as five-steps boxing itself has few movements, and so the quality of movements is naturally the first consideration.

重點提示：

（1）先掌握單個動作，然後再練習兩個動作以上的組合動作，並逐漸過渡到整套組合動作的練習。

（2）組合動作的練習，主要是鞏固和提高武術的基本動作，教學中先以步型、手型、手法的訓練為主，而後再逐漸做到"手、眼、身法、步"的協調一致。

（3）待動作熟練後，可左右勢互換，重複練習。

Important points:

1. Master a single movement first, then practice a combination of two or more movements, and gradually transition to a full set of combined movements.

2. The main aim of practicing combined movements is to consolidate and improve the basic movements of martial arts. Teaching focuses first on training stance, hand form, and technique, and then coordination of "hand, eye, body, step" is gradually achieved.

3. Once proficiency in movements is achieved, left and right forms can be exchanged and practiced repeatedly.

目　　錄
DIRECTORY

五步拳基本功
Five-steps fist basic skills

手型　Hand forms

一、拳 Fist

二、掌 Palm

三、勾 Hook

步型　Stances

一、馬步 Horse stance

二、弓步 Bow stance

三、歇步 Rest stance

四、僕步 Drop stance

五、虛步 Empty stance

手型　Hand forms

一、拳

各部位名稱：拳眼、拳心、拳面、拳背、拳輪

動作說明：五指卷緊，拇指壓於食指、中指第二指節上。

要點：拳握緊、拳面平、直腕。

易犯錯誤：拳面不平、屈腕。

糾正方法：理解拳的攻防作用。

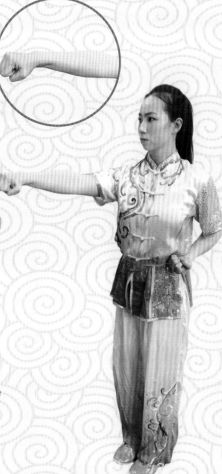

1. Fist

Name of each part: fist eye, fist heart, fist face, fist back, fist wheel.

Action description: the fingers are tightly rolled, with the thumb pressed on the second section of the index finger and middle finger.

Key points: fist clenched, fist face flat, wrist straight.

Easy-to-make mistakes: fist-face not flat, wrist bent.

Corrective method: explain the offensive and defensive functions of the fist.

二、掌

各部位名稱：掌心、掌背、掌指、掌根、掌外沿。

動作說明：四指伸直併攏，拇指彎曲緊扣於虎口處。

要點：掌心開展、豎指。

易犯錯誤：鬆指、掌背外凸。

糾正方法：理解掌的攻防作用。

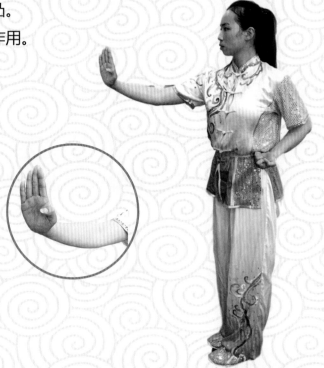

2. Palm

Name of each part: palm heart, palm back, palm fingers, palm root, palm edge.

Action description: the four fingers are straight and close together, the thumb is bent tight against the forefinger.

Key points: palm heart open, fingers pointing.

Easy-to-make mistakes: loose fingers, back of palm convex.

Corrective method: explain the offensive and defensive functions of the palm.

三、勾

各部位名稱：勾尖、勾頂。

動作說明：五指撮攏成勾，屈腕。

要點：屈腕。

易犯錯誤：鬆指，腕沒有扣緊。

糾正方法：理解勾手的攻防作用。

3. Hook

Name of each part: hook tip, hook top.

Action description: the five fingers are gathered into a hook, with the wrist bent.

Main point: bend your wrist.

Easy-to-make mistakes: loose fingers, wrist is not fastened.

Corrective method: explain the offensive and defensive functions of the hook.

步型　Stances

一、馬步

動作說明：兩腳左右開立約為腳長三～四倍，腳尖正對前方，屈膝半蹲，大腿成水平，眼看前方，兩手抱拳於腰間。

要點：頭正、挺胸、立腰、扣足。

1. Horse stance

Action description: the feet are about three or four feet apart, toes facing forwards, knees bent in a half-squat, looking forwards with the fists clenched beside the waist.

Key points: head erect, chest out, lower back upright, feet turned straight.

易犯錯誤和糾正方法：

(1) 腳尖外撇。

糾正方法：強調腳跟外蹬。

(2) 兩腳距離過大或太小。

糾正方法：量出三腳距離後，再下蹲成馬步。

(3) 彎腰跪膝。

糾正方法：強調挺胸、立腰後再下蹲，膝蓋不得超過腳尖。

Easy-to-make mistakes and corrective methods:

1. Toes pointing outwards.

Corrective method: emphasize on pressing heels outwards.

2. The distance between the feet is too large or too small.

Corrective method:
measure out the
distance of three
feet, then squat
into horse stance.

3. Waist bent or
kneeling.

Corrective method:
Emphasize chest
out, lower back
straight before
squatting, knees
should not be in
front of toes.

二、弓步

動作說明：前腳微內扣，全腳掌著地，屈膝半蹲，大腿成水平， 膝部約與腳面垂直；另一腿挺膝伸直，腳尖裡扣斜向前方，全腳掌著地，上體正對前方，兩手抱拳手腰間。

要點：挺胸，立腰；前腿弓、後腿繃。

易犯錯誤和糾正方法：

(1) 後腳拔跟或外掀腳掌。

糾正方法：強調腳跟蹬地。

(2) 後腿屈膝。

糾正方法：強調挺膝後蹬。

(3) 上體前傾。

糾正方法：強調沉髖。

2. Bow stance

Action description: The front foot is turned slightly inwards, the foot flat on the ground, the knee bent in a half-squat, the thigh level, so the knee is approximately perpendicular to the top of the foot; the other leg is outstretched with the knee nearly straight, the toes turned obliquely forward, the foot flat on the ground, the upper body is facing forwards, with the fists clenched beside the waist.

Key points: chest out, lower back upright; front leg arched, rear leg outstretched.

Easy-to-make mistakes and corrective methods:

1. Rear heel or outer edge of foot is lifted.

Corrective method: Emphasize on pressing heels outwards.

2. Rear knee bent.

Corrective method:

Emphasize push (kick) back to straighten knee.

3. Upper body leaning forwards.

Correction method: Emphasize on sinking hips.

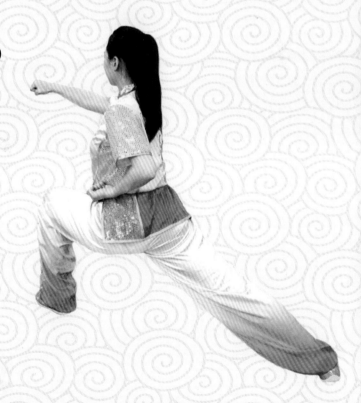

三、歇步

動作說明：兩腿交叉屈膝全蹲，前腳全腳掌著地，腳尖外展；後腳跟離地，臀部外側緊貼後小腿）。

要點：挺胸、立腰、兩腿貼緊。

易犯錯誤和糾正方法：

(1) 兩腿貼不緊，後腿膝跪地。

糾正方法：強調後腿膝關節穿過前膝胭窩。

(2) 動作不穩。

糾正方法：前腳尖充分外展、立腰、兩腿貼緊。

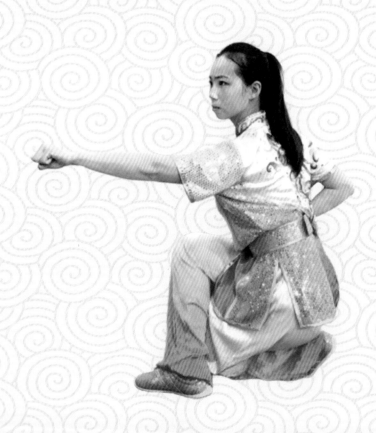

3. Rest stance

Action description: cross legs, bend knees and squat fully, front foot flat on the ground and toes turned outwards; rear heel off the ground and the buttocks close to the rear calf.

Key points: chest out, lower back upright, and keep legs tight together.

Easy-to-make mistakes and corrective methods:

1. The legs are not tight together, kneeling on the rear leg.

Corrective method: Emphasize the rear leg knee joint sits in the front knee hollow.

2. The movement is unstable.

Corrective method: toes of the front foot are fully turned outwards, the lower back upright, and the legs tight together.

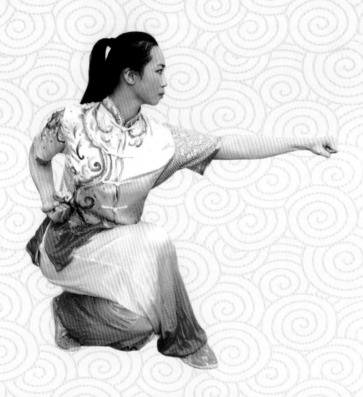

四、僕步

動作說明：一腿全蹲，大腿和小腿靠緊，臀部接近小腿，全腳 掌著地，膝與腳尖稍外展；另一腿平鋪接近地面，全腳掌著地， 腳尖內扣。

要點：挺胸、立腰、開髖，全腳掌著地。

易犯錯誤和糾正方法：

(1) 平鋪腿不直，腳外側掀起，腳尖上翹外展。

糾正方法：平鋪腿的腳外側抵住固定物，使之正確。

(2) 全蹲腿未蹲到底，腳跟提起。

糾正方法：增加踝關節柔韌性，強調腿平鋪時沉髖、擰腰。

(3) 上體前傾

糾正方法：挺胸、立腰後再下蹲。

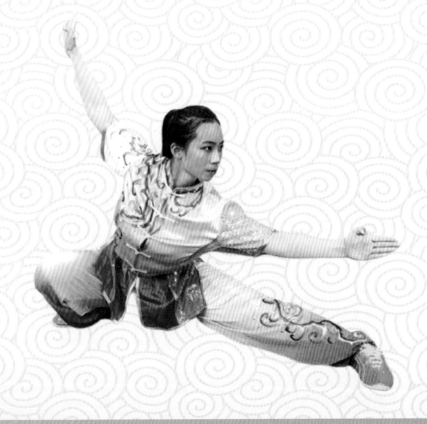

4. Drop stance

Action description: one leg squats, thigh and calf close together, buttocks close to the calf, foot flat on the ground, knee and toes slightly turned outwards; the other leg is close to the ground, foot flat on the ground, the toes turned inwards.

Key points: chest out, lower back straight, open hips, and feet flat on the ground.

Easy-to-make mistakes and corrective methods:

1. The extended leg is not straight, the outer edge of the foot is lifted, the toes are raised upwards.

Corrective method: flatten the outer edge of the foot against a fixture to correct the posture.

2. The squatting leg action is not fully completed, the heel is lifted.

Corrective method: increase the flexibility of the ankle joint, emphasize on sinking the hip and twisting the waist when the extended leg is laid flat.

3. Upper body leans forward

Corrective method: chest out, lower back upright before squatting.

37

五、虛步

動作說明：後腳尖斜向前，屈膝半蹲，大腿接近水準，全腳掌著地；前腿微屈，腳麵繃緊，腳尖虛點地面。

要點：挺胸、立腰、虛實分明。

易犯錯誤和糾正方法：

(1) 虛實不清。

糾正方法：等支撐腿下蹲後，前腳尖再著地。

(2) 支撐腿蹲不下去。

糾正方法：腳尖外展，多做腿部練習。

5. Empty stance

Action description: The toes of the rear foot are turned obliquely forward, the knee bent in a half-squat, the thigh close to level, and the foot flat on the ground; the front leg is slightly bent, the top of the foot taught, and the toes rest emptily on the ground.

Key points: chest out, lower back upright, and empty and solid aspects are clearly distinguished.

Easy-to-make mistakes and corrective methods:

1. Empty and solid aspects are not clearly distinguished.

Corrective method: first squat on the support leg, and then touch the toes of the front foot on the ground.

2. Unable to squat on the support leg.

Corrective method: turn toes outwards, do more leg exercises.

五步拳動作順序：

預備式 - 弓步沖拳 - 彈腿沖拳 - 馬步架打 - 歇步蓋打 - 提膝僕步穿掌 - 虛步挑掌 - 並步抱拳

預備式

兩腳併攏，雙手握拳抱於腰間，拳面與小腹在同一個平面，雙肘後頂，向左擺頭，目視左前方（圖1；圖2）。

要點： 挺胸，塌腰，收腹。

圖 1

Five-steps fist action sequence:

Preparatory form – twist bow stance punch fist – flick kick punch fist – horse stance lift strike – rest stance cover strike – lift knee drop stance pierce palm – empty stance raise palm – step together hold fists.

Preparatory form

Feet together, both hands make fists beside waist, fist face and lower abdomen in the same plane, push elbows back, swing head to the left, look forward to the left (Figures 1; 2).

Key points: sink waist, draw in belly.

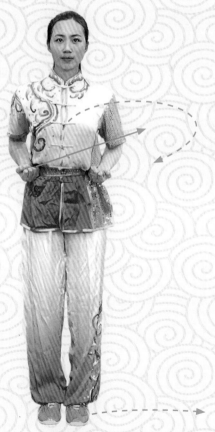

圖 2

一、弓步沖拳

1、馬步摟手: 左腳向左橫跨一大步成馬步, 同時左拳變掌向左摟出, 掌指朝上, 虎口撐開。目視左方 (圖3) 。

1. Bow stance punch fist

a. Horse stance gather arm: left foot take a big step across to the left and make a horse stance, at the same time left fist becomes palm gathering out to the left, fingers pointing upwards, thumb apart from forefinger, look to the left. (Figure 3)

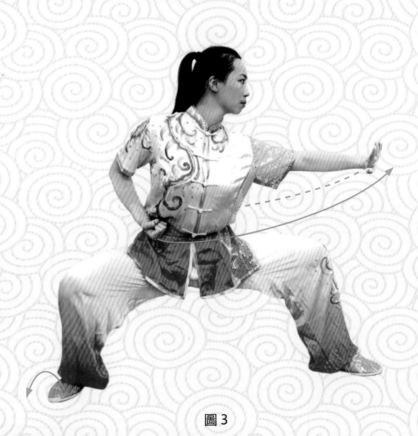

圖 3

2、弓步沖拳：左掌變拳收回腰間，拳心朝上。馬步向左擰腰轉胯成左弓步，右拳同時內旋擊出，拳心向下，力達拳面。目視前方（圖4）。

b. Bow stance punch fist: left palm becomes fist, draw back beside waist, fist-heart pointing upwards. From horse stance turn waist left and rotate hip to form left bow stance, at the same time rotate right fist inwards and strike outwards, fist heart downwards, expressing force through the fist face. Look forwards. (Figure 4)

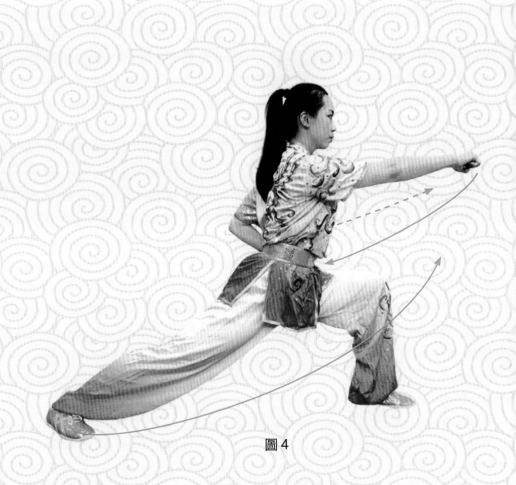

圖4

二、彈踢沖拳

右拳外旋收回腰間，拳心向上。左拳螺旋擊出，同時右腳向前彈出，腳面繃平，力達腳尖，左拳拳心向下，上身直立，目視前方（圖 5）。

2. Flick kick punch fist

Rotate right fist outwards and draw back beside waist, fist heart upwards. Rotate left fist inwards and strike outwards, fist heart downwards, at the same time flick right foot out to the front, upper foot stretched flat, expressing force through the toes, look forwards. (Figure 5)

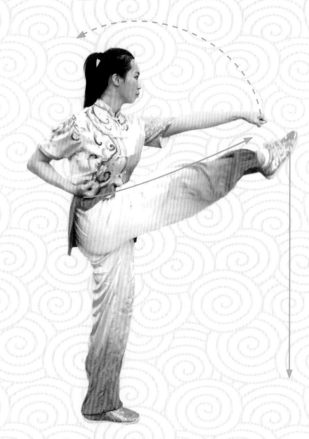

圖 5

三、馬步架打

右腳向前下落，身體向左轉體 90°，下蹲成馬步，左拳變掌向上撩架，右拳
向前擊出成平拳，眼看右方（圖 6）。

3. Horse stance lift strike

Drop right foot to front, turn body left by 90°, squat down to make horse
stance, left fist becomes palm, lift upwards, right fist strike out to the front
with fist flat, look to the right. (Figure 6)

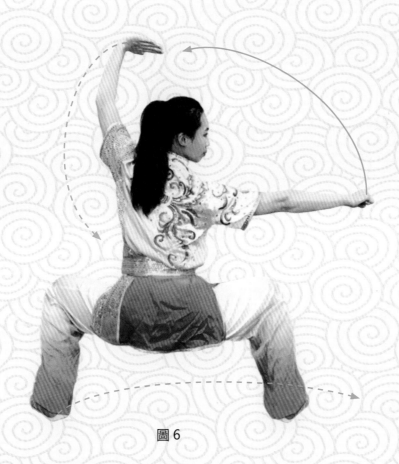

圖 6

四、插步蓋掌

轉身蓋掌: 向左轉身 90°，左腳後撤插至右腳後方，同時左掌變拳收回腰間，右拳變掌從上向左下橫蓋，掌外沿向前，目視前方（圖 7）。

4. Step in cover fist

Turn body cover palm: Turn body left by 90°, withdraw left foot to back of right foot. At the same time, left palm becomes fist, draw back beside waist, right fist becomes palm, in a stroke from above to lower left to cover, outer edge of palm forwards, look forwards. (Figure 7)

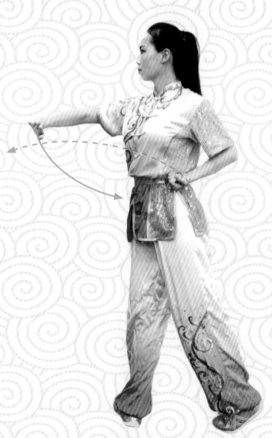

圖 7

五、歇步沖掌

歇步沖拳： 下蹲成右歇步，右掌變拳收回腰間，左拳平拳擊出，目視前方（圖 8）。

5. Rest stance punch fist

Squat down and make right rest stance, right palm becomes fist, draw back beside waist, left fist strike out with fist flat, look forwards. (Figure 8)

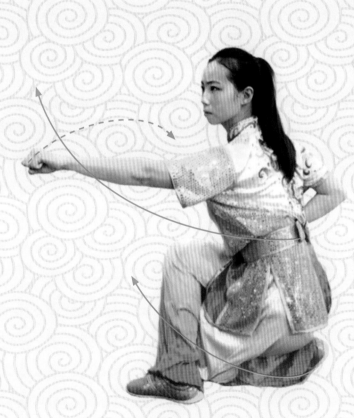

圖 8

六、提膝穿掌

左拳變掌下橫蓋，起身右腿直立，左腳提膝，同時右拳變掌從腰間向右上方穿出，目視右掌（圖9）。

6. Lift knee pierce palm

Left fist becomes palm, stroke downwards to cover, rise on right leg to stand upright, lift left knee, at the same time right fist becomes palm, pierce from beside waist out to upper right, look in direction of right palm. (Figure 9)

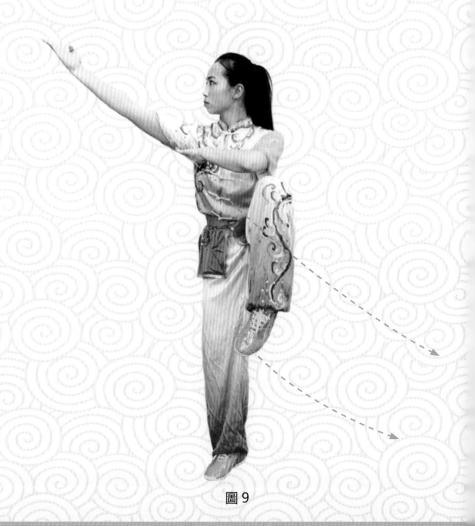

圖 9

七、僕步穿掌

左腳向左落步成左僕步，左掌向左下方穿出，目視左方（圖 10）。

7. Drop stance pierce palm

Drop left foot down to the left and make left drop stance, pierce left palm out
to lower left, look to the left. (Figure 10)

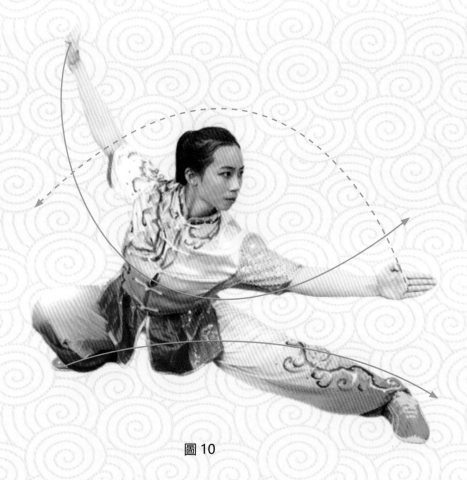

圖 10

八、虛步挑掌

右腳向前上步成右虛步，左掌順勢向上向後成下勾手(低不過肩，高不過耳端)。右掌向前向上挑出，掌指向上，右肘微曲，目視前方（圖11）。

8. Empty stance raise palm

Bring right foot forward and make right empty stance, left palm draw upwards and backwards to make hook (between shoulder and ear level). Raise right palm forward, fingers pointing upward, right elbow slightly curved, look forwards. (Figure 11)

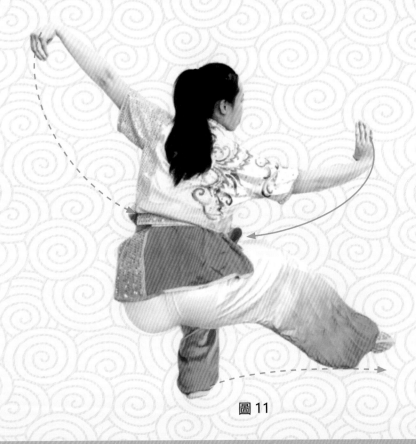

圖 11

九、收式接背面預備式

1、左腳向右腳併攏，雙手變拳收回腰間，目視前方（圖 12）。

2、雙手握拳抱於腰間，拳面與小腹在同一個平面，雙肘後頂，向左擺頭，目視左前方（圖 12）。

要點： 挺胸，塌腰，收腹。

9. Closing form and reverse view of preparatory form

a. Bring left foot alongside right foot, both hands become fists, draw back beside waist, look forwards. (Figure 12)

b. Feet together, both hands make fists beside waist, fist face and lower abdomen in the same plane, push elbows back, swing head to the left, look forward to the left (Figures 12).

Key points: chest out, sink waist, draw in belly.

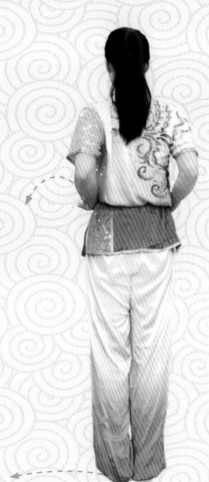

圖 12

十、弓步沖拳

1、馬步摟手: 左腳向左橫跨一大步成馬步, 同時左拳變掌向左摟出, 掌指朝上, 虎口撐開。目視左方（圖 13）。

10. Bow stance punch fist

a. Horse stance gather arm: left foot take a big step across to the left and make a horse stance, at the same time left fist becomes palm gathering out to the left, fingers pointing upwards, thumb apart from forefinger, look to the left. (Figure 13)

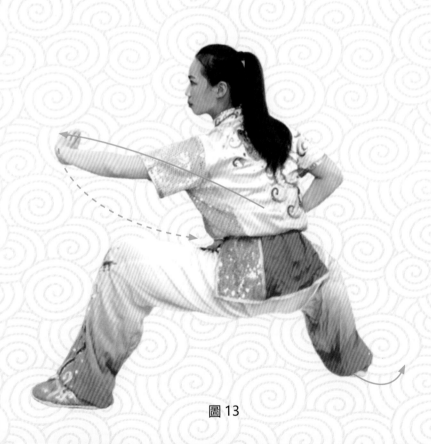

圖 13

2、弓步沖拳：左掌變拳收回腰間，拳心朝上。馬步向左擰腰轉胯成左弓步，右拳同時內旋擊出，拳心向下，力達拳面。目視前方（圖14）。

b. Bow stance punch fist: left palm becomes fist, draw back beside waist, fist-heart pointing upwards. From horse stance turn waist left and rotate hip to form left bow stance, at the same time rotate right fist inwards and strike outwards, fist heart downwards, expressing force through the fist face. Look forwards. (Figure 14)

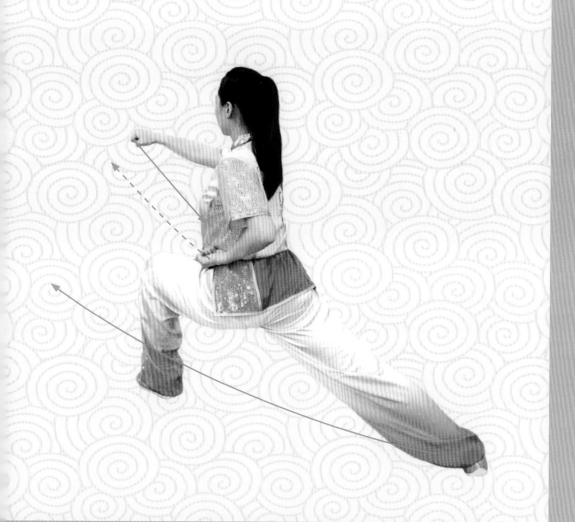

十一、彈踢沖拳

右拳外旋收回腰間，拳心向上。左拳螺旋擊出，同時右腳向前彈出，腳面繃平，力達腳尖，左拳拳心向下，上身直立，目視前方（圖 15）。

11. Flick kick punch fist

Rotate right fist outwards and draw back beside waist, fist heart upwards. Rotate left fist inwards and strike outwards, fist heart downwards, at the same time flick right foot out to the front, upper foot stretched flat, expressing force through the toes, look forwards. (Figure 15)

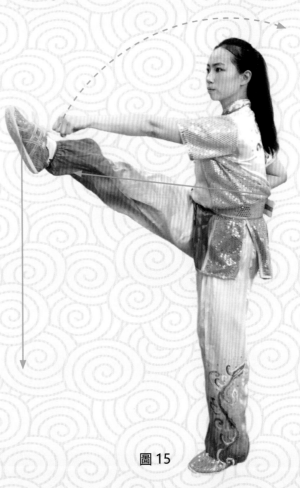

圖 15

十二、馬步架打

右腳向前下落，身體向左轉體 90°，下蹲成馬步，左拳變掌向上撩架，右拳向前擊出成平拳，眼看右方（圖 16）。

12. Horse stance lift strike

Drop right foot to front, turn body left by 90°, squat down to make horse stance, left fist becomes palm, lift upwards, right fist strike out to the front with fist flat, look to the right. (Figure 16)

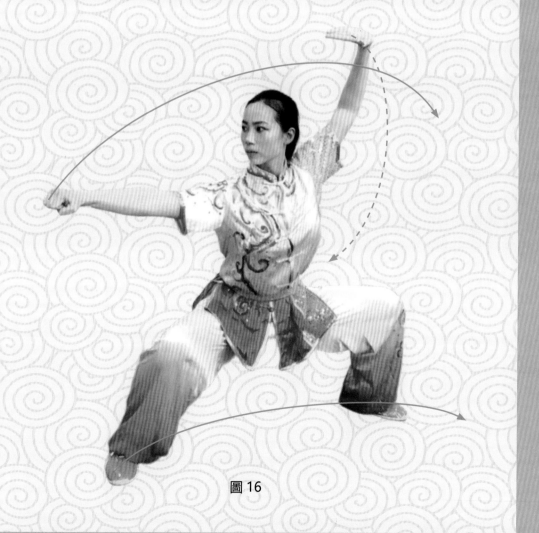

圖 16

十三、插步蓋掌

轉身蓋掌： 向左轉身 90°，左腳後撤插至右腳後方，同時左掌變拳收回腰間，右拳變掌從上向左下橫蓋，掌外沿向前，目視前方（圖 17）。

13. Step in cover fist

Turn body cover palm: Turn body left by 90°, withdraw left foot to back of right foot. At the same time, left palm becomes fist, draw back beside waist, right fist becomes palm, in a stroke from above to lower left to cover, outer edge of palm forwards, look forwards. (Figure 17)

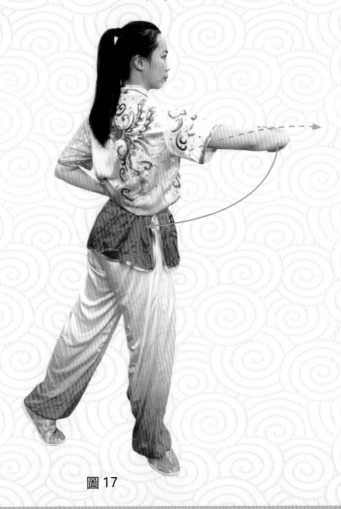

圖 17

十四、歇步沖拳

歇步沖拳：下蹲成右歇步，右掌變拳收回腰間，左拳平拳擊出，目視前方（圖 18）。

14. Rest stance punch fist

Squat down and make right rest stance, right palm becomes fist, draw back beside waist, left fist strike out with fist flat, look forwards. (Figure 18)

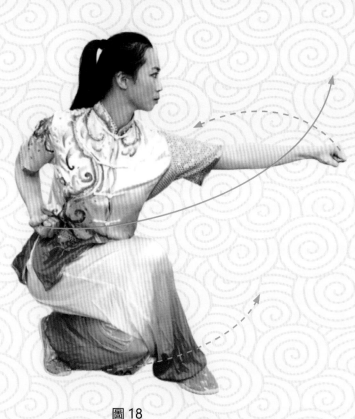

圖 18

十五、提膝穿掌

左拳變掌下橫蓋，起身右腿直立，左腳提膝，同時右拳變掌從腰間向右上方穿出，目視右掌（圖 19）。

15. Lift knee pierce palm

Left fist becomes palm, stroke downwards to cover, rise on right leg to stand upright, lift left knee, at the same time right fist becomes palm, pierce from beside waist out to upper right, look in direction of right palm. (Figure 19)

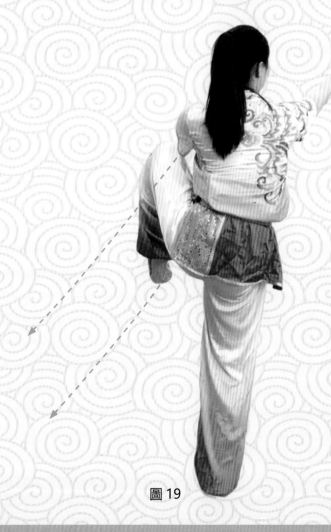

圖 19

十六、僕步穿掌

左腳向左落步成左僕步，左掌向左下方穿出，目視左方（圖 20）。

16. Drop stance pierce palm

Drop left foot down to the left and make left drop stance, pierce left palm out to lower left, look to the left. (Figure 20)

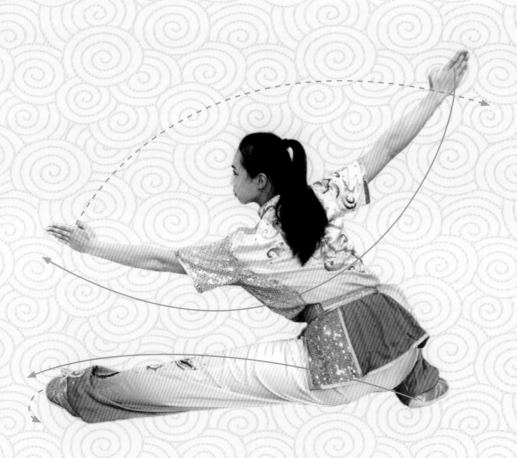

圖 20

十七、虚步挑掌

右脚向前上步成右虚步，左掌顺势向上向後成下勾手（低不過肩，高不過耳端）。右掌向前向上挑出，掌指向上，右肘微曲，目視前方（圖21）。

17. Empty stance raise palm

Bring right foot forward and make right empty stance, left palm draw upwards and backwards to make hook (between shoulder and ear level). Raise right palm forward, fingers pointing upward, right elbow slightly curved, look forwards. (Figure 21)

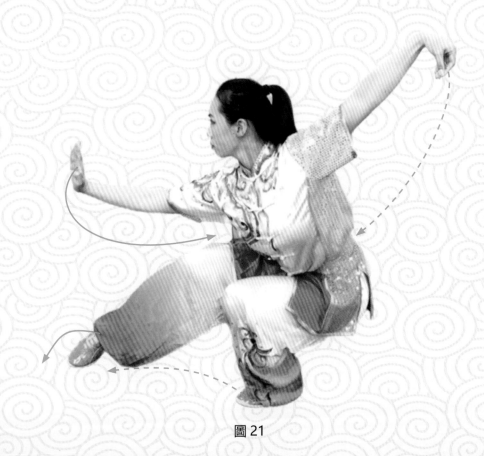

圖 21

收式

左腳向右腳併攏，雙手變拳收回腰間，目視前方（圖 22）。

Closing form

Bring left foot alongside right foot, both hands becomes fists, draw back beside waist, look forwards. (Figure 22)

圖 22

五步拳連續動作圖

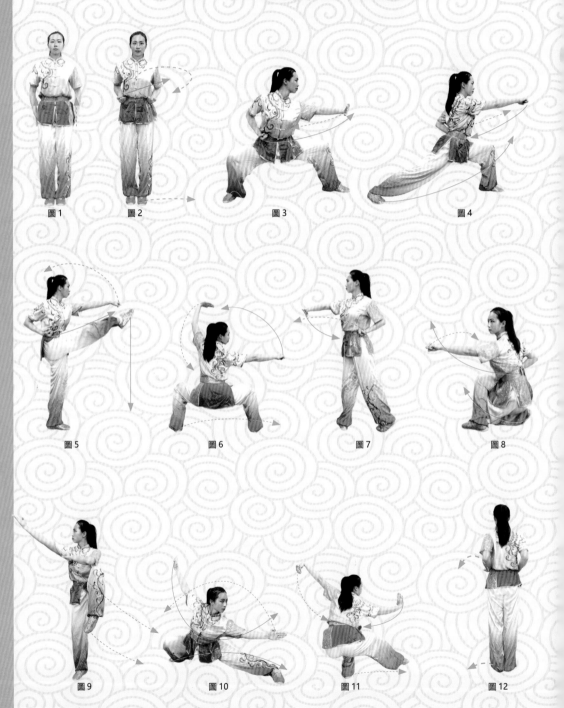

圖 1 　　圖 2 　　圖 3 　　圖 4

圖 5 　　圖 6 　　圖 7 　　圖 8

圖 9 　　圖 10 　　圖 11 　　圖 12

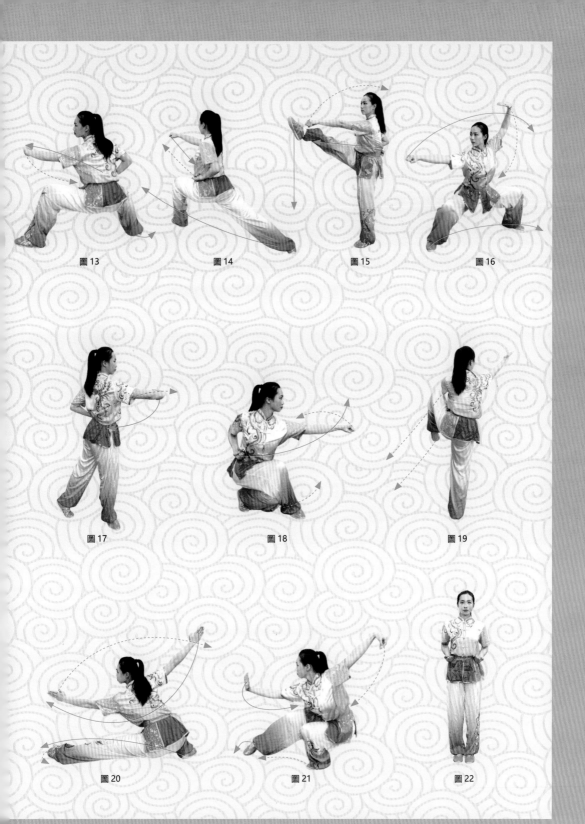

圖 13　　　　　圖 14　　　　　圖 15　　　　　圖 16

圖 17　　　　　　圖 18　　　　　　圖 19

圖 20　　　　　　圖 21　　　　　　圖 22

【太極羊・專業武術鞋】

兒童款・超纖皮

打開淘寶APP

掃碼進店

XF808-1 銀

XF808-1 白

XF808-1 紅

XF808-1 金

XF808-1 藍

XF808-1 黑

XF808-1 粉

微信掃一掃

進入小程序購買

短袖款

长袖款

【高端休閑太極鞋】

兩種顏色選擇·男女同款

軍綠色

深藍色

 打開淘寶天貓APP
掃碼進店

 微信掃一掃
進入小程序購買

【武術/表演/比賽/專業太極鞋】

打開淘寶天貓
掃碼進店

微信掃一掃
進入小程序購買

正紅色【升級款】
XF001 正紅

藍色【經典款】
XF8008-2 藍

黃色【經典款】
XF8008-2 黃色

紫色【經典款】
XF8008-2 紫色

正紅色【經典款】
XF8008-2 正紅

黑色【經典款】
XF8008-2 黑

綠色【經典款】
XF8008-2 綠

桔紅色【經典款】
XF8008-2 桔紅

粉色【經典款】
XF8008-2 粉

XF2008B（太極圖）白

XF2008B（太極圖）黑

XF2008-2 白

XF2008-3 黑

5634 白

XF2008-2 黑

【學校學生鞋】

多種款式選擇 · 男女同款

可定制logo

香港及海外掃碼購買

檢測報告　　　　商品注册證

【專業太極服】

多種款式選擇·男女同款

微信掃一掃
進入小程序購買

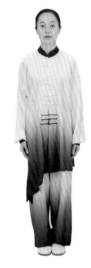

黑白漸變仿綢

淺棕色牛奶絲

白色星光麻

亞麻淺粉中袖

白色星光麻

真絲綢藍白漸變

【武術服、太極服】

多種顏色選擇．男女同款

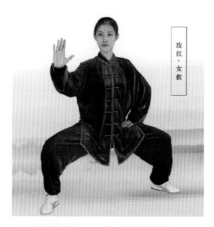
玫紅．女款

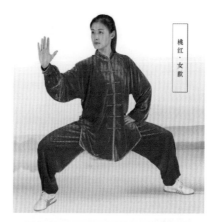
桃紅．女款

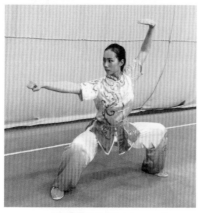

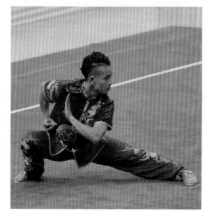

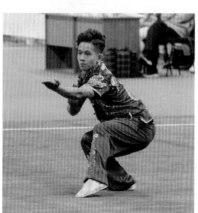

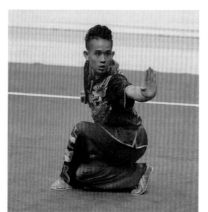

【專業太極刀劍】

晨練/武術/表演/太極劍

手工純銅太極劍

神武合金太極劍

桃木太極劍

平板護手太極劍

手工銅錢太極劍

鏤空太極劍

手工純銅太極劍

神武合金太極劍

劍袋‧多種顏色、尺寸選擇

銀色八卦圖伸縮劍

銀色花環圖伸縮劍

龍泉寶刀

棕色八卦圖伸縮劍

紅棕色八卦圖伸縮劍

70

【太極扇】

武術/廣場舞/表演扇

可訂制LOGO

紅色牡丹

粉色牡丹

黃色牡丹

紫色牡丹

黑色牡丹

藍色牡丹

綠色牡丹

黑色龍鳳

紅色武字

黑色武字

紅色龍鳳

金色龍鳳

純紅色

紅色冷字

紅色功夫扇

紅色太極

打開淘寶天貓APP

掃碼進店

微信掃一掃

進入小程序購買

香港國際武術總會裁判員、教練員培訓班
常年舉辦培訓

　　香港國際武術總會培訓中心是經過香港政府注冊、香港國際武術總會認證的培訓部門。爲傳承中華傳統文化、促進武術運動的開展，加强裁判員、教練員隊伍建設，提高武術裁判員、教練員綜合水平，以進一步規範科學訓練爲目的，選拔、培養更多的作風硬、業務精、技術好的裁判員、教練員團隊。特開展常年培訓，報名人數每達到一定數量，即舉辦培訓班。

報名條件：熱愛武術運動，思想作風正派，敬業精神强，有較高的職業道德，男女不限。

培訓內容：1.規則培訓；2.裁判法；3.技術培訓。考核內容：1.理論、規則考試；2.技術考核；3.實際操作和實踐（安排實際比賽實習）。經考核合格者頒發結業證書。培訓考核優秀者，將會錄入香港國際武術總會人才庫，有機會代表參加重大武術比賽，并提供宣傳、推廣平臺。

聯系方式

深圳：13143449091（微信同號）
　　　13352912626（微信同號）
香港：0085298500233（微信同號）

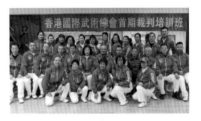

國際武術教練證

國際武術裁判證

微信掃一掃

進入小程序

香港國際武術總會第三期裁判、教練培訓班

打開淘寶AP

掃碼進店

【正版教學光盤】

正版教學光盤 太極名師 冷先鋒 DVD包郵

深圳市坪山湯坑小學

學校座落在馬巒山下，占地面積 37402 ㎡，環境優美，設備精良。有藝體中心（1600 ㎡），電腦教室、科學實驗室、100 兆對等網路、童心創客室等 26 個功能室。共有 33 個班，學生 1516 人；教師 94 人，研究生學歷 2 人，本科 85 人，教師學歷達標率 100%。有全國首屆百優名師 1 人，省級優秀教師 1 人，市優秀教師 5 人，市"十佳班主任"1 人，區年度教師提名獎 2 人，區級"十佳班主任"1 人，"十佳師德標兵"2 人，"十佳青年教師"1 人，區名師 8 人，區級骨幹教師 3 人，區教壇新秀 1 人。區優秀教師 18 人，區級優秀班主任 15 人，其中高級教師 1 人，一級教師 42 人。校級友善幸福名師 16 名，骨幹 13 名，新秀 12 名。

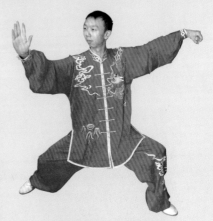

總教練：冷余

【辦學特色】

1、課堂改革：引進教育部重點課題基於學習科學理論的友善用腦幸福課堂；引進全國"深度學習"工作團隊，開展深度學習課堂教學研究。
2、班級管理：實行創建幸福班級，提高學生校園幸福感。
3、科技教育：引進以色列 Stream、人工智慧、玩轉發明等科技專案。
4、幸福德育：開展"播種微笑"德育系列活動，引進《幸福修身》和《國學十德》課程。
5、英語教學：實施快樂英語和英文繪本閱讀試點學校。
6、閱讀書法：開展"我愛閱讀"校本課程和書法考級。
7、體藝特色：師生普及太極拳，學生文體社團 50 多個，普及率 100%。

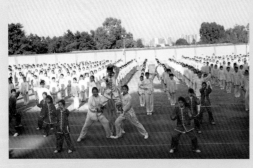
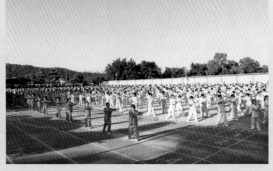

湯坑小學

办学目标：

让每位孩子享受金色童年的快乐与幸福

教育理念：

践行"幸福教育"

——珍视童年生命价值；

——尊重每一位孩子的人格；

——真正促进每一位孩子个性发展。

教育口号：

你的成长，就是我的幸福！

幸福汤小 金色童年

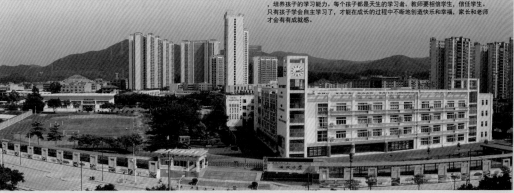

地址：坪山新區湯坑社區同裕路 1 號

聯繫電話：0755-84536329

傳真：0755-84536129

RMKG每月學校簡介會(深灣校)

報名請掃描上方QR二維碼或致電2795 1018
幼稚園及幼兒園課程9月正式接受報名!

Prenatal	1-4 months	4-12 months	12-18 months	18-36 months	3-6 years
BabyPlus and Prenatal Education Programme	Baby Connection Programme	Intelligence Multiplier Programme English/PTH	Brainy Tots Programme English & PTH	Rightmind Programme English & PTH	Immersion Classes English/PTH

右思維國際幼兒園暨幼稚園(RMKG)與**KinderU**均為右腦學習的模式，因此**KinderU**學生能及早適應課程，建立優越的記憶系統，順利銜接右思維國際幼兒園暨幼稚園的學習。

右思維國際幼兒園暨幼稚園(RMKG)

是一所提倡右腦學習的幼稚園，著重品德培養，從兩歲班開始誦讀弟子規、大學、論語，從小教導學生注意紀律，尊敬師長、友愛弟妹。

課程特色

- 英語及普通話浸淫式學習
- 以數點卡學習數學基礎概念
- 課程從生活主題擴展至世界百科知識
- 誦讀弟子規、大學、論語，實踐品德培養
- 多元化音樂課程，從小認識樂理知識
- 課外學習西班牙語、法語、舞蹈及太極

KinderU是一間著重胎教及右腦發展的學前教育中心，致力提供各項益智有趣的活動，讓幼兒在有助刺激感觀發展的環境中，盡情探索不同質感、聲音及事物。通過右腦教學法，全面促進幼兒早期的腦部及身體發展，激發幼兒具備的潛能。

課程特色

- 對象為出生前至6歲的兒童
- 以英語及普通話授課
- 運用字卡、數學點卡等，幫助發展右腦構圖及計算能力
- 透過親子瑜珈及太極以及多樣化器材訓練兒童肌肉發展
- 初步接觸外語如法語及西班牙語

欲知更多課程資料，請即瀏覽本校網址 (www.rmkg.edu.hk)

深灣分校
香港深灣道11號雅濤閣地下
Tel: 2795 1018
2970 2382

海怡半島分校
香港鴨脷洲海怡半島第四期26-28座地下上層
Tel: 2875 0452
2554 7576

【出版各種書籍】

中英文版
English
★★★★

申請書號>設計排版>印刷出品
>市場推廣
港澳台各大書店銷售

冷先鋒

《國際武術大講堂系列教學》
《校園武術普及教材－五步拳》

香港先鋒國際集團　審定

太極羊集團　　赞助

香港國際武術總會有限公司　出版

香港聯合書刊物流有限公司　發行

代理商：台灣白象文化事業有限公司

書號：ISBN 978-988-74212-8-3

香港地址：香港九龍彌敦道 525 -543 號寶寧大廈 C 座 412 室

電話：00852-95889723 \91267932

深圳地址：深圳市羅湖區紅嶺中路 2018 號建設集團大廈 B 座 20A

電話：0755-25950376\13352912626

台灣地址：401 台中市東區和平街 228 巷 44 號

電話：04-22208589

印次：2020 年 11 月第一次印刷

印數：5000 冊

總編輯：冷先鋒

責任編輯：余芷瑄

責任印制：冷修寧

版面設計：明栩成

圖片攝影：王振名

網站：https://taijixf.com　　www. taijiyanghk.com

Email: lengxianfeng@yahoo.com.hk